DRAW 500

THINGS
FROM
NATURE

A Sketchbook for Artists, Designers, and Doodlers

ELOISE RENOUF

Quarry Books
100 Cummings Center, Suite 406L
Beverly, MA 01915

quarrybooks.com • craftside.typepad.com

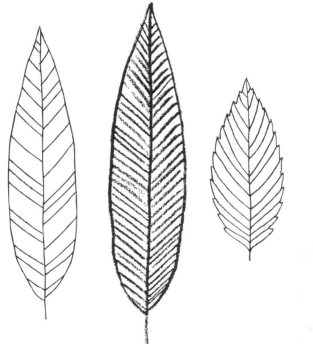

HOW TO USE THIS BOOK

This book features 500 drawings of beautiful, textured, leafy, winged, and crawly things from nature. You will see that most of these drawings are comprised of simple combinations of lines and shapes. When you look at a natural object you want to draw, what do you see? Are there squares, circles, or triangles? Are the outlines of the shape straight, curved, or wiggly? When drawing flowers, trees, or animals, for example, look for the big shapes and lines first, and then add in the smaller details.

Use the illustrations in this book as inspiration. You can trace them, copy them, or change the details to draw your own versions. There's plenty of blank space to draw right in the book, so grab a pencil, pen, marker, or brush, commune with nature, and have fun drawing lots of flora and fauna of your own!

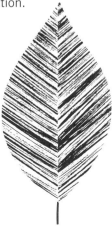

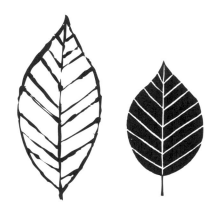

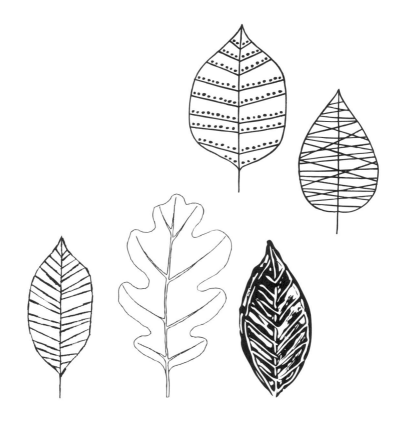

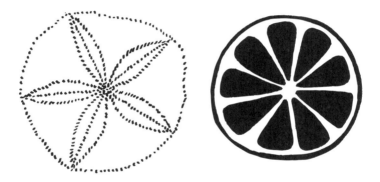

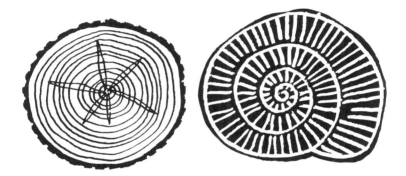

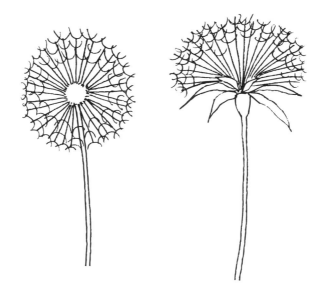

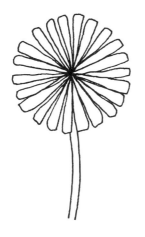
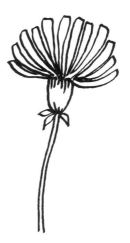

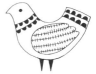

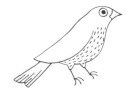

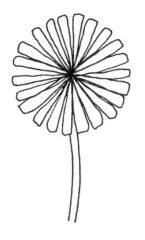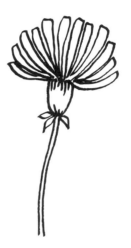

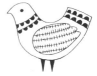

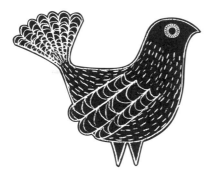

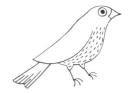

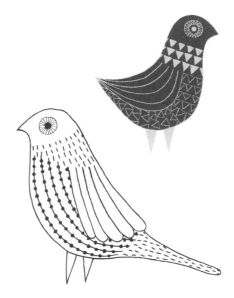

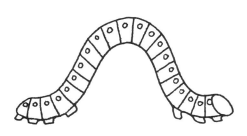

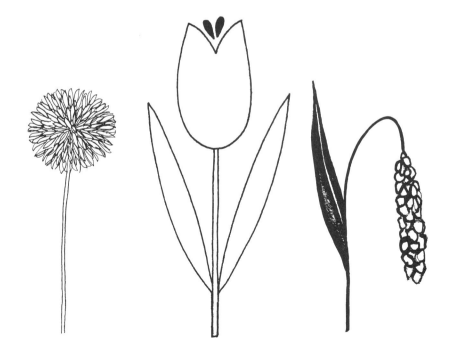

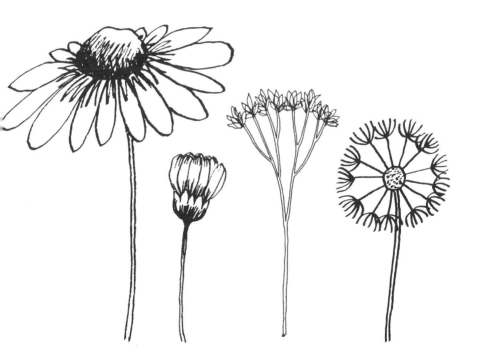

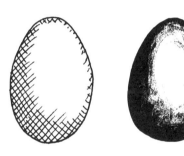

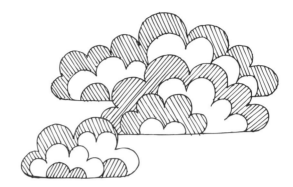

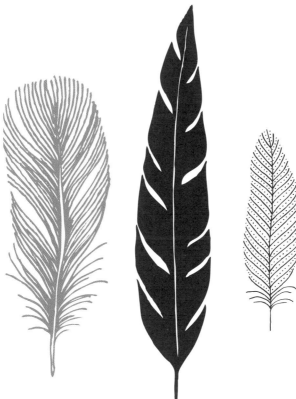

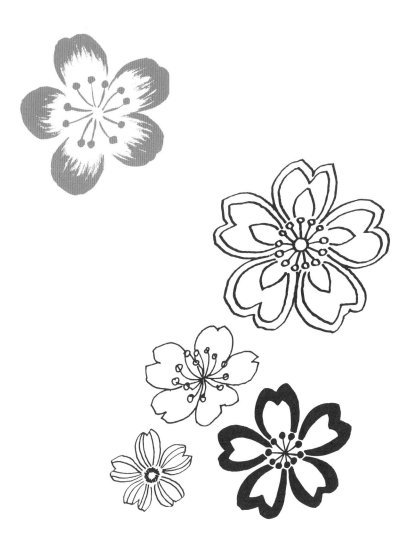

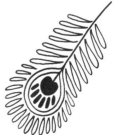

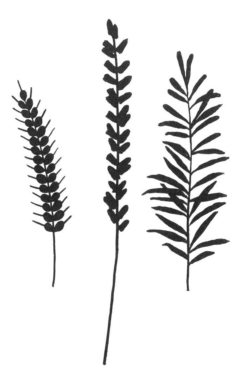

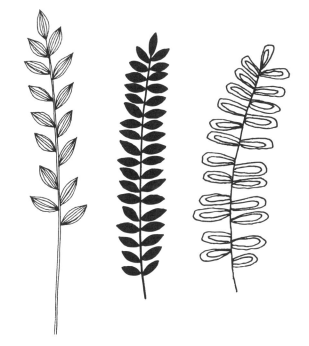

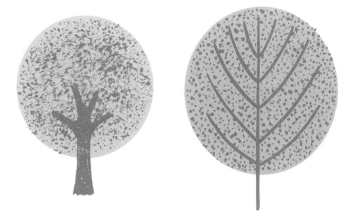

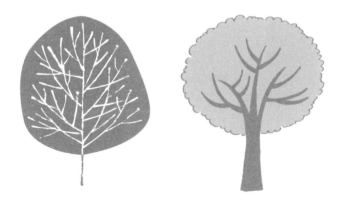

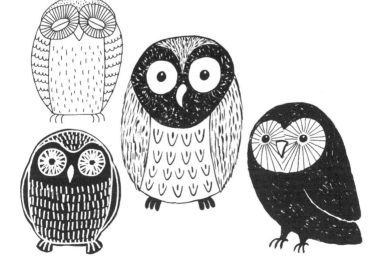

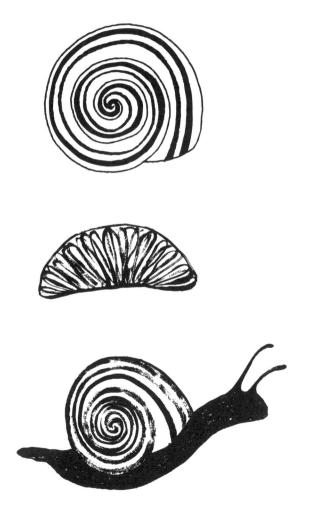

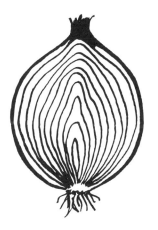

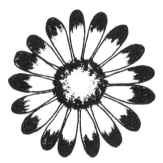

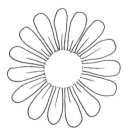

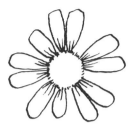

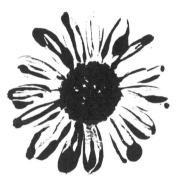

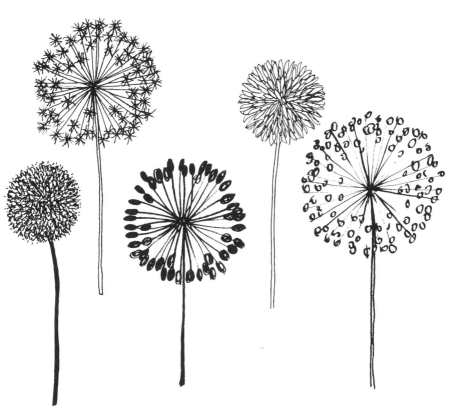

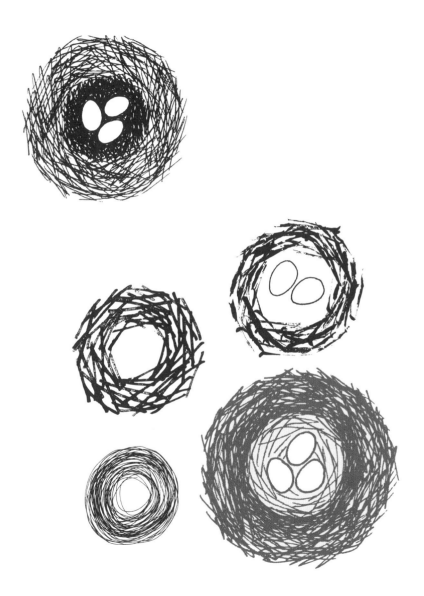

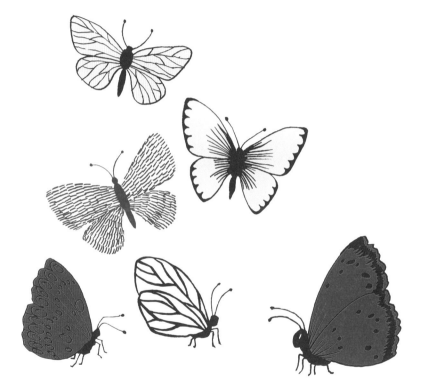

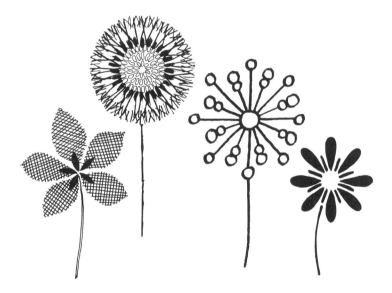

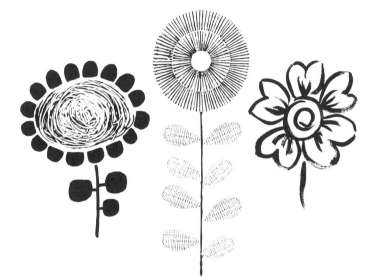

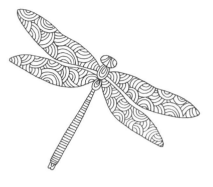

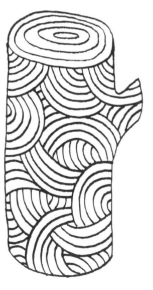

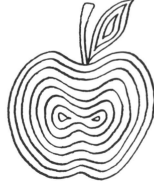

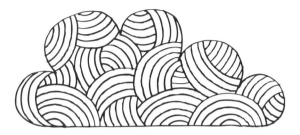

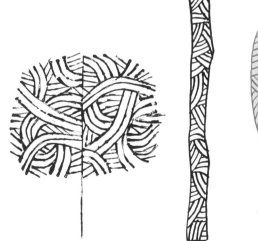

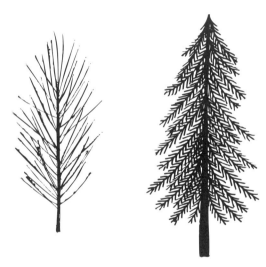

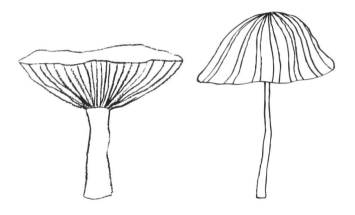

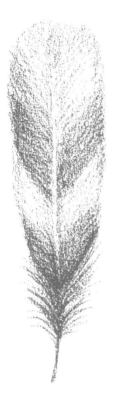

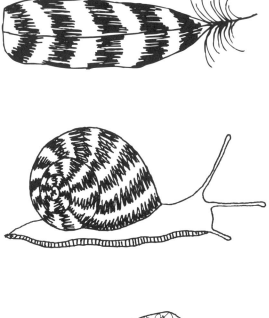

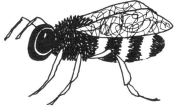

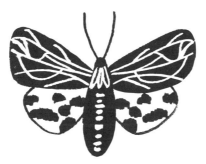

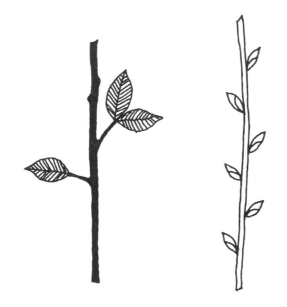

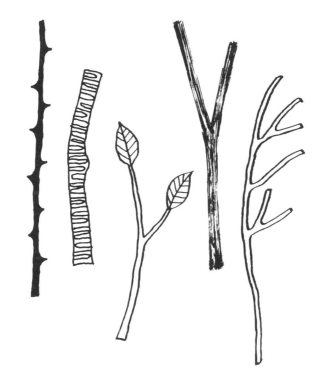

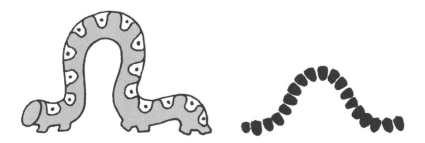

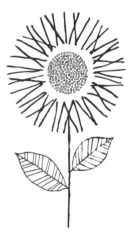
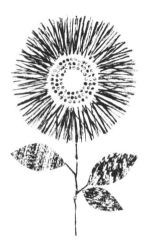

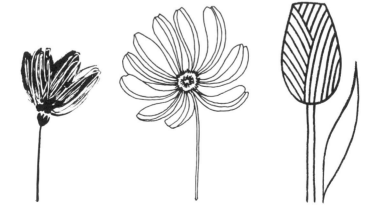

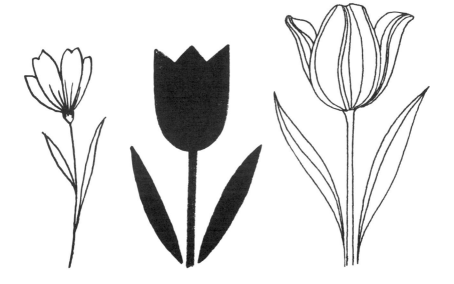

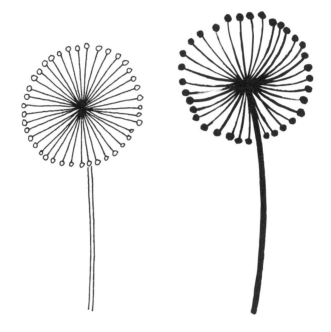

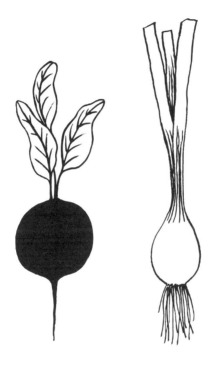

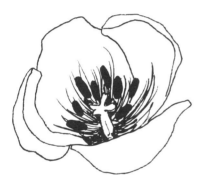
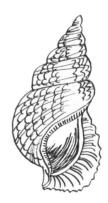

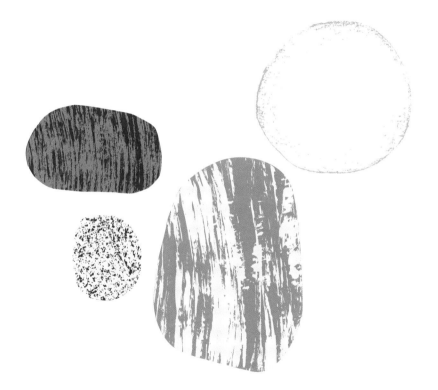

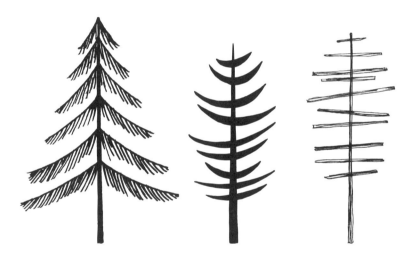

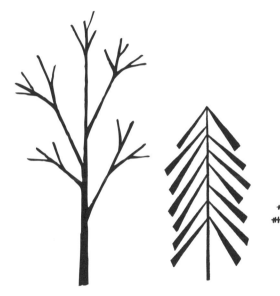

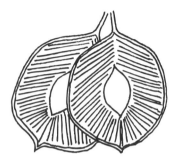

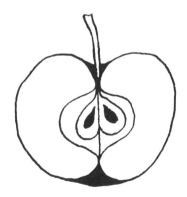

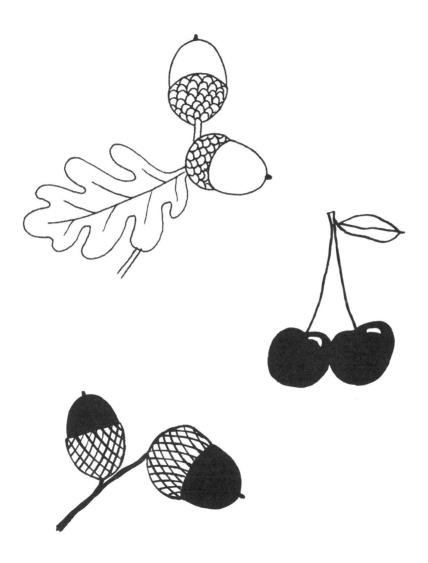

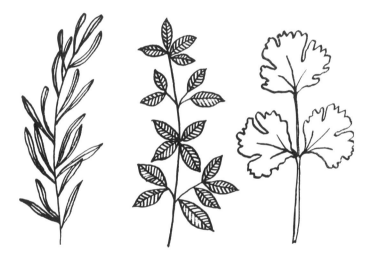

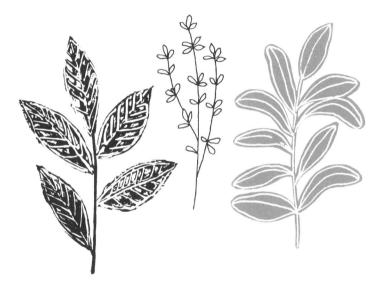

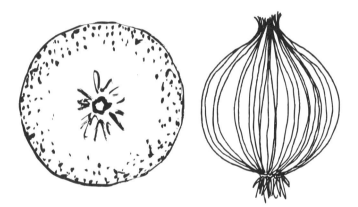

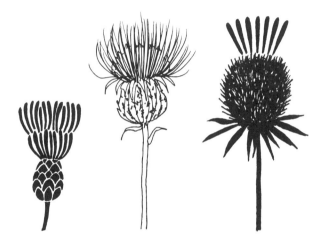

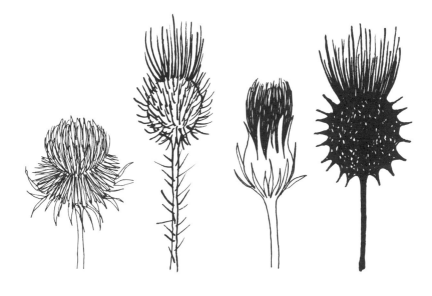

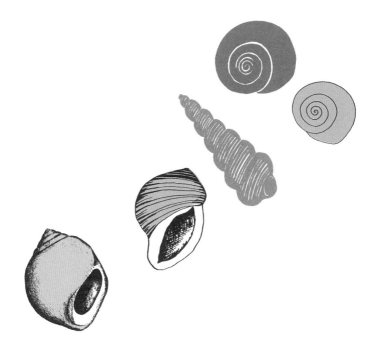

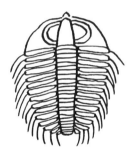 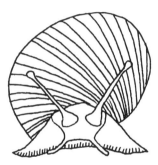

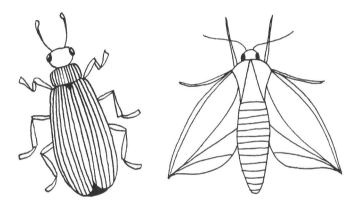

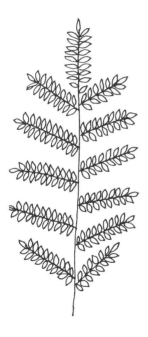

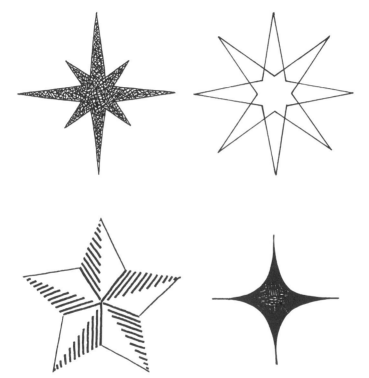

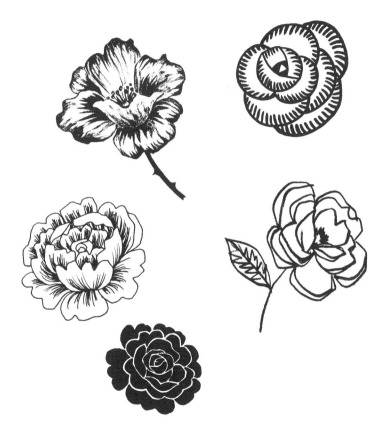

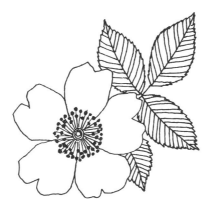

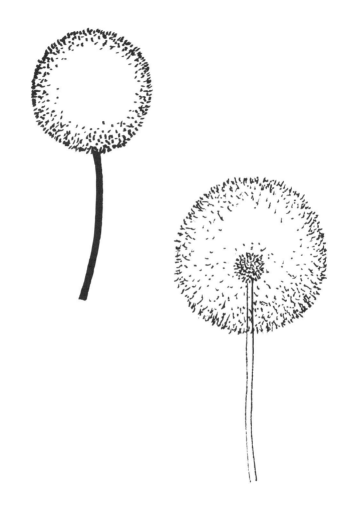

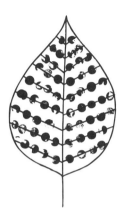
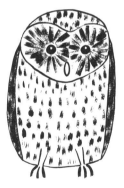

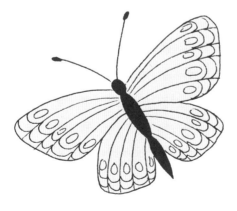

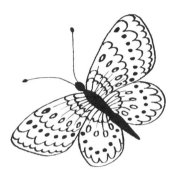
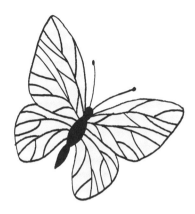

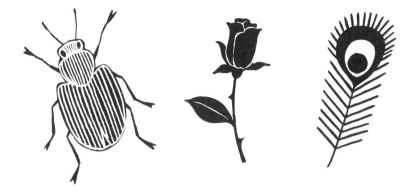

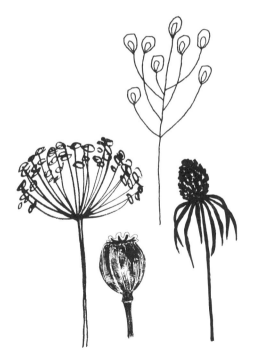

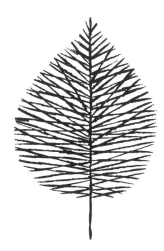

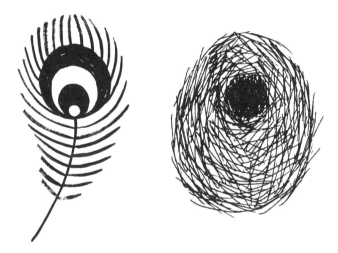

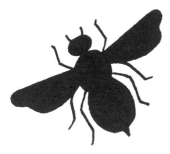

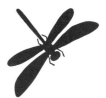

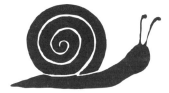

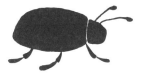

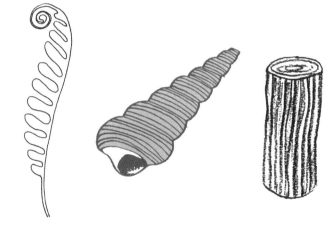

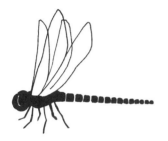

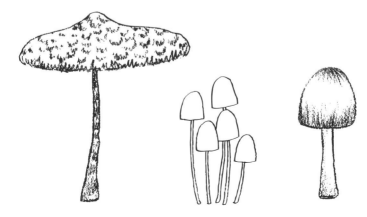

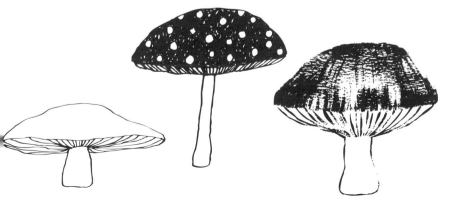

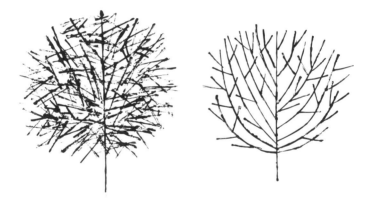

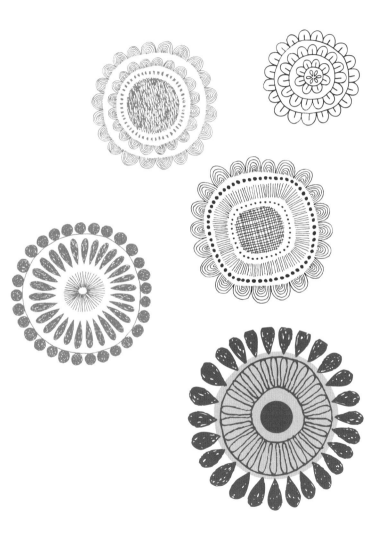

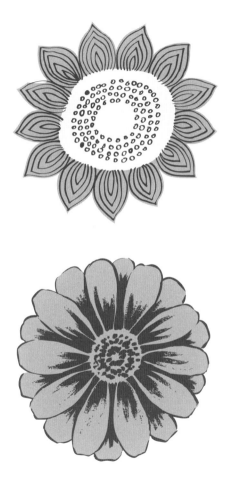

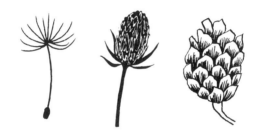

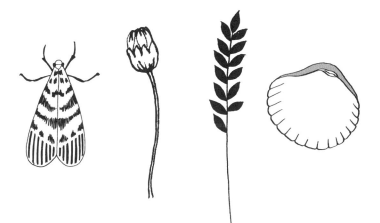

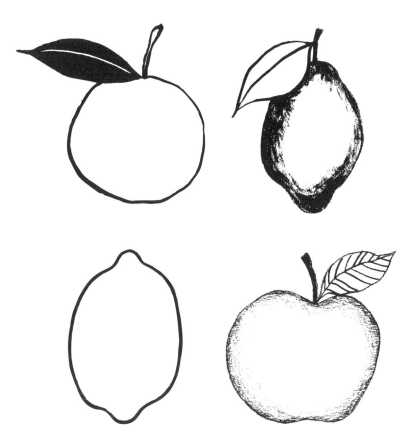

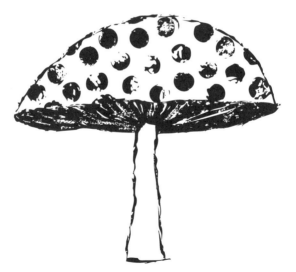

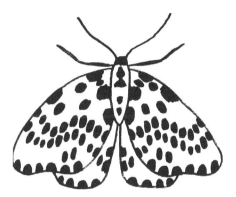

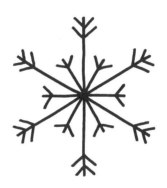

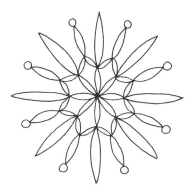

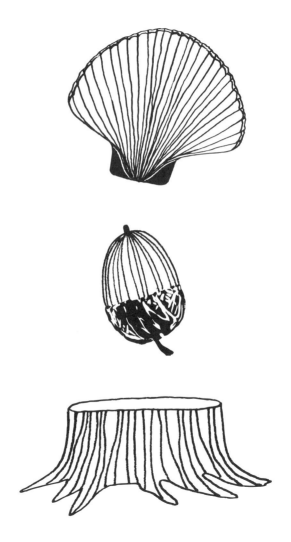

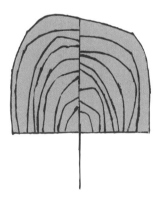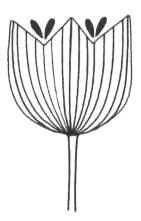

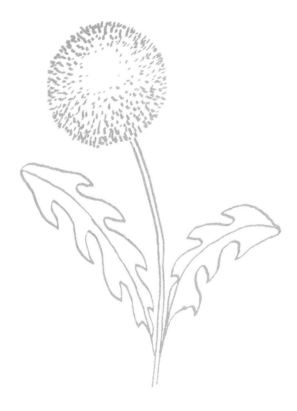

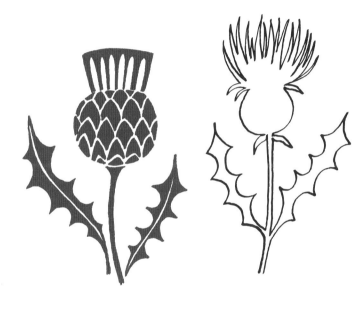

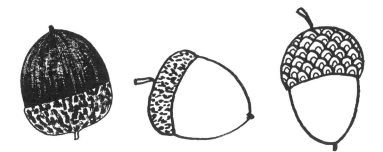

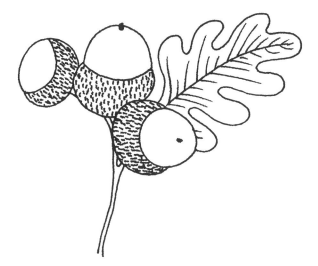

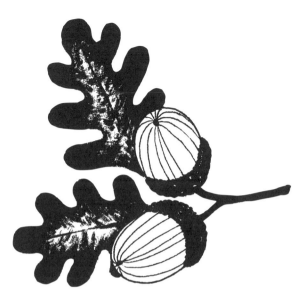

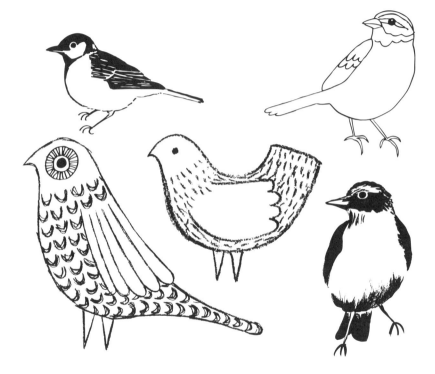

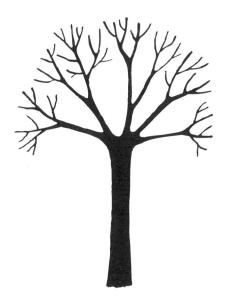

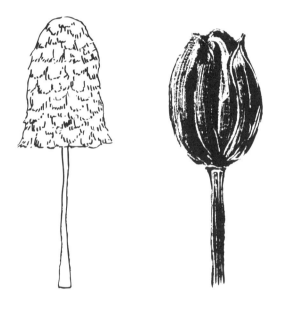

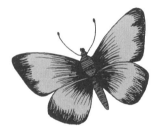

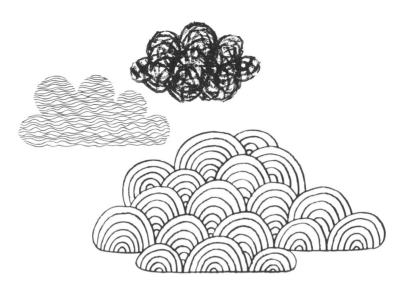

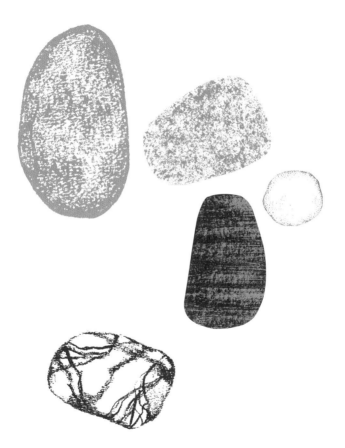

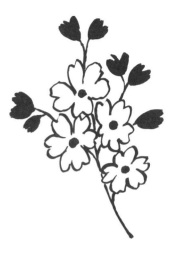

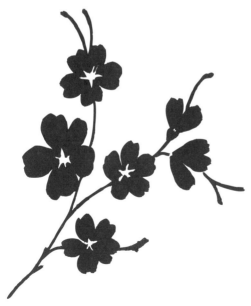

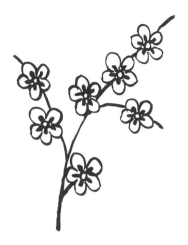

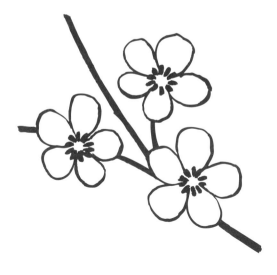

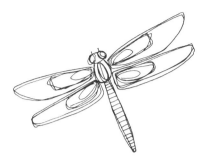

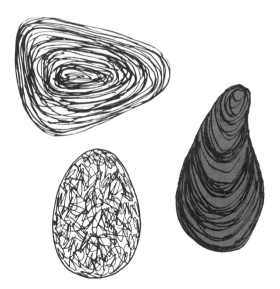

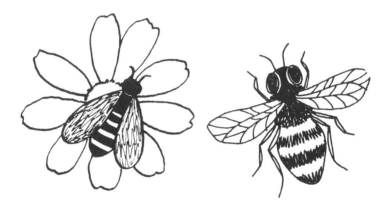

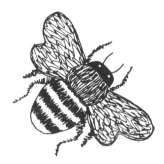

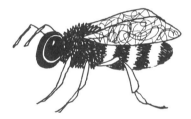

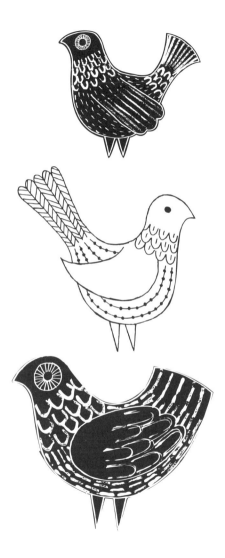

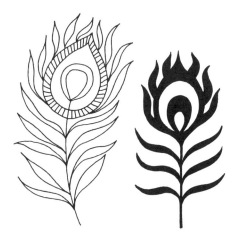

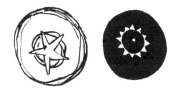

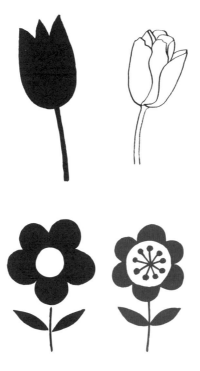

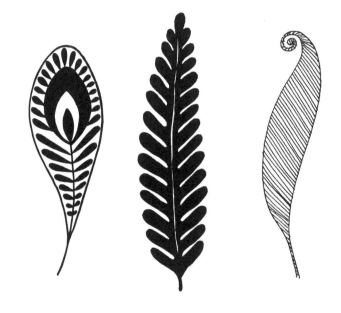

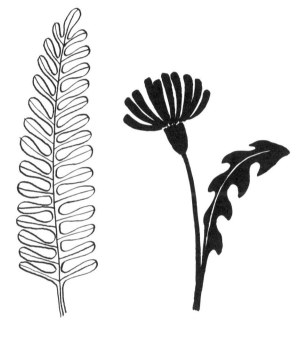

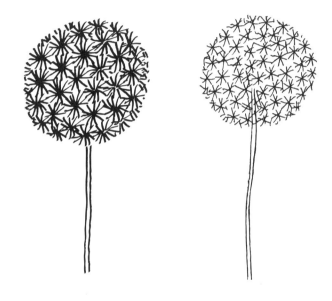

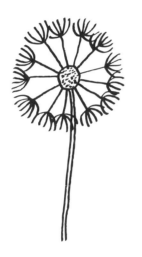

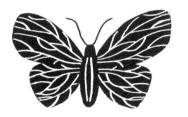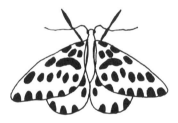

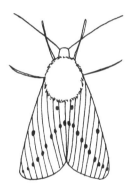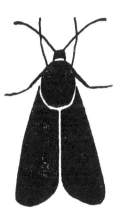

ABOUT THE ARTIST

Eloise Renouf graduated with a degree in printed textile design from Manchester Metropolitan University, UK. She worked as a fashion print designer in studios in both London and New York before establishing her own stationery company in 2000. She now designs and sells her own range of limited-edition prints and fabric accessories, whilst also undertaking commission and licensing work for homewares, stationery, and illustration. She lives and works in Nottingham, England, with her partner and three children. See more of her work at **www.eloiserenouf.etsy.com**

© 2014 by Quarry Books
Illustrations © 2013 Eloise Renouf

First published in the United States of America in 2014 by
Quarry Books, a member of
Quarto Publishing Group USA Inc.
100 Cummings Center
Suite 406-L
Beverly, Massachusetts 01915-6101
Telephone: (978) 282-9590
Fax: (978) 283-2742
www.quarrybooks.com
Visit www.Craftside.Typepad.com for a
behind-the-scenes peek at our crafty world!

10 9 8 7 6 5 4 3 2

ISBN: 978-1-59253-989-5

All artwork compiled from *20 Ways to Tree and 44 Other
Nifty Things from Nature*, Quarry Books, 2013

Design: Debbie Berne

Printed in China